ALASTAIR SOOKE is deputy art critic of the *Daily Telegraph*. He has written and presented documentaries on television and radio for the BBC, including *Modern Masters*, an acclaimed BBC One series that chronicled modern art in the twentieth century. Since 2009 he has reported regularly for *The Culture Show* on BBC Two. He was educated at Christ Church, Oxford, and at the Courtauld Institute of Art, London.

ALASTAIR SOOKE

Roy Lichtenstein

*How Modern Art was Saved
by Donald Duck*

PENGUIN BOOKS

PENGUIN BOOKS

Published by the Penguin Group
Penguin Books Ltd, 80 Strand, London WC2R 0RL, England
Penguin Group (USA) Inc., 375 Hudson Street, New York, New York 10014, USA
Penguin Group (Canada), 90 Eglinton Avenue East, Suite 700, Toronto, Ontario, Canada M4P 2Y3
(a division of Pearson Penguin Canada Inc.)
Penguin Ireland, 25 St Stephen's Green, Dublin 2, Ireland (a division of Penguin Books Ltd)
Penguin Group (Australia), 250 Camberwell Road,
Camberwell, Victoria 3124, Australia (a division of Pearson Australia Group Pty Ltd)
Penguin Books India Pvt Ltd, 11 Community Centre,
Panchsheel Park, New Delhi – 110 017, India
Penguin Group (NZ), 67 Apollo Drive, Rosedale, Auckland 0632, New Zealand
(a division of Pearson New Zealand Ltd)
Penguin Books (South Africa) (Pty) Ltd, Block D, Rosebank Office Park, 181 Jan Smuts Avenue,
Parktown North, Gauteng 2193, South Africa

Penguin Books Ltd, Registered Offices: 80 Strand, London WC2R 0RL, England

www.penguin.com

First published 2013
002

Copyright © Alastair Sooke, 2013

The moral right of the author has been asserted

Printed in Great Britain by Clays Ltd, St Ives plc

ISBN: 978-0-241-96604-4

For Katharine

Contents

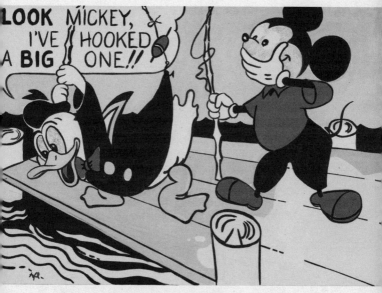

Look Mickey (1961)

Introduction:
'Mr Lichtenstein, it's time for your pills'

A man and a woman are contemplating a work of art. I say 'man' and 'woman', but they don't resemble real people – they look like cartoons. They are considering a painting – we know that because we can see the edges of the canvas tacked to a wooden stretcher frame, which is the same unnatural yellow as the woman's hair. But we can't make out its subject, because it has been turned to catch the light coming through a large, slanting window in the background: we are in an artist's studio, benefiting from copious daylight. Still, we assume that the painting must be good, because the young man, presumably the artist gazing in profile at his handiwork, appears slightly smug. He is classically handsome, like Barbie's companion, Ken. Ignoring his girlfriend, lost in narcissistic reverie, he has the blank expression of an automaton. To win his attention, the woman coquettishly tilts back her pretty face, with its high cheekbones, almond-sleek blue eyes and full, red lips. 'Why, Brad darling,' she says. 'This painting is a masterpiece! My, soon you'll have all of New York clamoring for your work!'

Her words provide the title for the real-life picture, of which she is a part: *Masterpiece*. When this scene was painted in 1962, it must have seemed like a provocative joke. For one thing, the painting's title is self-consciously perverse. Many of us have a sense of what a masterpiece looks like, and this

overblown panel from a throwaway comic strip surely isn't it. Where is the subtle brushwork of the Old Masters – the exquisite painterly touch of Titian, Velázquez or Rembrandt? *Masterpiece* is flat and mechanical, like the comics it is imitating. A speech bubble filled with overemphatic capital letters and exclamation marks obscures the top third of the picture. Aside from someone with a boring name like Brad, what sort of artist would bother to record such banality?

The answer, of course, is another painter with a monosyllabic forename: the American artist Roy Lichtenstein (1923–97), who is known as the architect of Pop art. In the Sixties, Lichtenstein became famous for painting cartoons. To begin with, this made certain people very angry. *Masterpiece*, then, was a defensive gag at the artist's own expense. But Lichtenstein's witticism was also spiked with ambition and prophetic irony. Within a few years, New York did start clamouring for his work, and the painting's fantasy of wish fulfilment coalesced into reality. *Masterpiece* became a masterpiece of contemporary art.

The canvas belongs to two related series known as the *War* and *Romance* paintings, which Lichtenstein began in the early Sixties. Together they remain his most memorable achievements: when people think of Lichtenstein, they are usually thinking of these pictures. The *War* paintings were inspired by trashy publications such as the *All-American Men of War* comic books that were popular during the Fifties. Lichtenstein transformed the illustrations in their pages into exhilarating images of ice-cool jet pilots in dogfights, submariners unleashing torpedoes, and heavy weaponry surrounded by onomatopoeic sound effects such as TAKKA TAKKA and BRATATAT! In *Whaam!* (1963), a diptych that is a perennial crowd-pleaser in the Tate, a faceless hotshot releases a rocket that screams from left to right before destroying an enemy fighter jet, which explodes in a dramatic fireball of red and yellow. It is a tongue-in-cheek male daydream of aggression, conquest and ejaculatory release.

The *Romance* paintings, which draw upon DC Comics' *Girls'*
Romances and *Secret Hearts* series, present heartache about
relationships rather than action. In these pictures, Lichtenstein
painted cute young women, often in close-up, frequently disap-
pointed in love. According to the titles, his girls are 'frightened',
'anxious' or 'hopeless'. Many of them cry. Unlike the decisive
heroes of the *War* paintings, they hesitate, stammer ('M-Maybe'),
and mumble and stumble on the phone ('Ohhh . . . Alright . . .';
'Oh, Jeff . . . I Love You, Too . . . But . . .'). Sometimes they are
lovelorn, waiting for a sweetheart beside an alarm clock that
signifies the endless creep of time. Occasionally they are dis-
traught. In *Drowning Girl* (1963), Lichtenstein's blue-haired
heroine sinks in a whirlpool that we understand to be a schlocky
symbol of her roiling, negative emotions.

The 'hot' subject matter of both series – the frenzied activity
of warfare, the all-consuming turbulence of puppy love – con-
trasts with the 'cool' manner in which they are painted. This
tension between style and content became Lichtenstein's trade-
mark. By the early Sixties the artist had perfected his much-
imitated look, which would sustain his career until his death. It
is instantly recognizable, consisting of a restricted, artificial
palette of flat, simple colours (red, yellow and blue, with occa-
sional green), heavy black outlines and the use of fields of tiny
coloured dots, which replicate the cheap commercial printing
techniques commonly found in newspaper advertisements,
comic strips, mail-order catalogues, product packaging and
pulp magazines. Lichtenstein applied paint in a highly control-
led manner – unlike his immediate predecessors in American
art, the Abstract Expressionists, who included Jackson Pollock
and Willem de Kooning. 'Whatever quality one generation has
is boring to the next generation,' Lichtenstein said in 1965.
'And so you look for something else.'

As a result, his pictures often feel ironic. Why else would a
painter labour for so long over a cartoon? Surely *Whaam!* isn't
a straightforward celebration of war but a bathetic statement
about the absurdity of conflict? (It may be significant that it was

painted just as America's involvement in the Vietnam War was gearing up.) *Drowning Girl* isn't meant to be moving; it's a sally upon mass-media melodrama. Right?

It is true that Lichtenstein's *War* and *Romance* paintings satirize the media's endless reinforcement of gender stereotypes. In *Masterpiece*, for instance, the taciturn artist is the hero, while his gushing blonde admirer is a sidekick, adorning his accomplishment. She speaks, but her words are all chatter and puff, designed to lure his regard. (It doesn't seem to be working.) By contrast, he has created something enduring and important: a masterpiece. Machismo and talent versus female passivity: these were the oppositional values enshrined in popular culture that shaped a generation's understanding of what it meant to be a man or a woman in mid-twentieth-century America. By mimicking the appearance of that culture, Lichtenstein exposed its shallow psychology and sexist rhetoric. He was inviting us to laugh.

But people tend to forget that he largely stopped painting comics around 1966, when dialogue balloons disappeared from his work. This was only five years after his breakthrough Pop painting, *Look Mickey*, yet he still had another three decades of his career to go. He started to concentrate on paintings that were explicitly concerned with art history, such as his 1968–9 canvases based on Monet's *Haystacks* and *Rouen Cathedral* series.

In other words, yes, he wanted to dismantle clichés of popular culture. But he wasn't drawn only to vernacular imagery: many different aspects of visual culture caught his eye. One day, he imitated the conventions of comic books; the next, he examined Monet's stylistic tics. It didn't matter whether he was considering 'high' or 'low' culture, *All-American Men of War* comics or Impressionist haystacks. For Lichtenstein, each had become as hackneyed as the other. His motivation was usually consistent: to analyse why things looked the way they did. In short, his enduring subject was style.

But we are jumping ahead of ourselves. In order to understand why Lichtenstein was so interested in style, we need to

learn about his own stylistic development. And to do that, we need to find out more about his life. In this book, I am going to write about an exciting transformation: how a jobbing, uncertain painter of the Fifties became a world-famous Pop artist whose mechanical paintings ended up selling for tens of millions of pounds. In May 2012, *Sleeping Girl* (1964), one of Lichtenstein's *Romance* paintings, sold at auction for almost $44.9 million (£27.8 million) – a record for the artist. Though he won recognition in his own lifetime, Lichtenstein never strutted or took it for granted. According to his second wife, Dorothy Lichtenstein (née Herzka): 'He used to say, "I know somebody's going to shake me, and I will still be Roy but I will be in a wheelchair, and they will say, 'Mr Lichtenstein, it's time for your pills,' and this will all have been a dream – that success."'

Beginnings: 'I was an old-fashioned artist'

Unlike his artistic hero Pablo Picasso, Lichtenstein did not lead a life full of gossip, intrigue and scandal. He didn't have a 'Bluebeard complex', which was the memorable diagnosis assigned to Picasso by one of his many lovers. By all accounts, Lichtenstein was a polite and measured man who cherished routine and never shied away from grunt-work in the studio. Occasionally he ventured into sculpture: during the Sixties he produced painted ceramic coffee cups and shop mannequin heads decorated with dots, as well as star-shaped *Explosions* made of enamel and steel. His witty *Modern* sculptures of 1967–8, constructed out of brass fittings, glass, mirrors and velvet ropes, deserve greater recognition. But first and foremost Lichtenstein was a painter.

In this respect, he was the opposite of his famous contemporary Andy Warhol, who 'retired' from painting in 1965 to concentrate on other activities, including making movies, managing a rock band and publishing a magazine. Warhol may have been detached and voyeuristic, but he presided over Dionysian excess in the Factory. He represented creative freedom, and radically expanded the possibilities of what an artist could do and be. Lichtenstein was different. He was the classicist of the Pop movement, forever fascinated by form. Throughout his career he exerted Apollonian control over his

canvases; in 1963 the British art critic David Sylvester described him as the heir to the classical French painter Poussin. 'I was an old-fashioned artist compared with [Warhol],' Lichtenstein once said, recalling a Sixties fancy-dress Halloween party that he attended as Andy Warhol, spraying his hair with silver paint, powdering his face to look as pale as possible and wearing sunglasses. Usually, though, he was anything but flamboyant. 'Roy was very reserved,' Dorothy Lichtenstein said in 2008. 'His personality was not at all like the images. He wasn't boisterous or noisy.'

Most mornings Lichtenstein would arrive in his studio by ten o'clock. When he broke for lunch, he'd often visit the same nearby restaurant: after moving to Washington Street in New York City in 1988, he patronized Florent, a popular 24-hour diner, almost every day. According to Dorothy Lichtenstein, 'He worked in a very steady way. He used to say he aspired to become unpredictable and wild, curmudgeonly even, but it wasn't his nature.'

Roy Fox Lichtenstein was born in Manhattan in 1923. His father, Milton, a first-generation German-Jewish American, was a real-estate broker. Beatrice, his mother, also of German-Jewish descent, was a housewife who played the piano to a high standard. Lichtenstein grew up on New York's Upper West Side. As a boy, he enjoyed visiting the American Museum of Natural History and listening to popular radio programmes such as *Flash Gordon*. He drew from a young age. When he was a teenager, he attended watercolour classes on Saturday mornings. With his mother and sister, he visited the Museum of Modern Art, where he admired Picasso's *Guernica* in 1939.

In 1940, after graduating from Franklin, a private high school in Manhattan, he enrolled at Ohio State University, where he attended influential drawing classes taught by Professor Hoyt L. Sherman. In 1945 Sherman created his 'flash lab', which would have a lasting impact upon Lichtenstein. Using a nineteenth-century mechanical device known as a 'tachistoscope', Sherman projected images on to a screen inside a darkened studio

converted from an old artillery shed. Each image would appear for a fraction of a second before darkness returned, and Sherman's students were then invited to draw from memory the after-image that had passed across their retinas. In each class, Sherman would 'flash' twenty slides. At first, he presented simple abstract shapes. But, as the six-week course continued, he gradually introduced increasingly complex images, from Old Master drawings to three-dimensional still lifes that he had constructed with the help of assistants. The idea was to teach students to recognize the underlying compositional unity of what they saw.

Although Lichtenstein never completed a full course in the flash lab, he taught in it and built his own version after joining Ohio State's School of Fine and Applied Arts as an instructor in 1946. (He also tried to re-create the flash lab while he was assistant professor of art at two other institutions in the late Fifties.) In 1963, a couple of years after his transition into Pop, Lichtenstein said: 'The ideas of Professor Hoyt Sherman on perception were my earliest important influence and still affect my ideas of visual unity.' The importance of unity in his work is something that Lichtenstein stressed throughout his life. Moreover, it is tempting to link the intense impact of his Pop works, which burst on to the retina with the ferocity of a flash-bulb, to the lessons he learned from Sherman.

Lichtenstein was at Ohio State for most of the Forties, first as a student, then as a teacher – except for a few years, between 1943 and 1946, when he was in the US Army. To begin with, he was posted to an anti-aircraft training base in Texas. The following year, he was sent to Keesler Air Force Base in Mississippi to train as a pilot. Perhaps the seeds of his interest in aerial combat were sown during this period: his *War* paintings would be full of fighter jets.

After the training programme at Keesler was unexpectedly cancelled, Lichtenstein reported for duty at the Mississippi headquarters of the 69th Infantry Division of the Ninth Army. One of his informal duties was to enlarge cartoons in the Army newspaper *Stars and Stripes* for his commanding officer – almost

two decades before he would make his name with paintings that looked like enlarged cartoons. (Lichtenstein never explained why he had to do this; perhaps his officer was short-sighted.) He also worked as a draughtsman. By chance, his drawings caught the eye of an officer at boot camp called Irv Novick, who took Lichtenstein off latrine-mopping duty, and got him to design posters and signs instead. After the war, Novick became a successful comic-book artist. Years later his artwork would provide a source for many of Lichtenstein's paintings, including *Whaam!*

Above all, though, Lichtenstein's stint in the Army offered an opportunity to expand his understanding of art history. At the end of 1944 his division was shipped to Europe. After stopping off in London, where he saw exhibitions of Cézanne and Toulouse-Lautrec, and bought a book on Chinese painting (fifty years before his series of more than twenty landscapes in the manner of Song Dynasty scroll paintings), Lichtenstein arrived in France. His combat tour subsequently took him to Belgium and Germany. In Paris he bought books about Goya and Seurat, as well as three portfolios of reproductions of etchings by Rembrandt. He also visited the Louvre.

In October 1945, after the city had been liberated, Lichtenstein decided to visit Picasso's studio on the rue des Grands-Augustins. When he got there, however, he couldn't bring himself to knock on the door. 'I was actually afraid to go in,' he later recalled. 'There was a big gate and there was a paper mill or something on part of it, it was very closed off. I think actually at that time Picasso was not seeing GIs any longer.' The episode offers insight into Lichtenstein's character, and records the high esteem in which he already held Picasso in his early twenties. 'I think Picasso is the greatest artist of the twentieth century by far,' he said much later, in 1988. 'Is there any real doubt about that? I think he had just more magic, more insanity, more images, more styles, greater production than many others.'

Lichtenstein returned to America at the end of 1945 upon hearing about the serious illness of his father, who died a few

weeks later. On being discharged from the Army, he returned to Ohio State to complete his degree, before joining the faculty. We tend to assume that great artists arrive fully formed, but in Lichtenstein's case this was not so: he would be thirty-seven before he began to paint in his idiosyncratic style. In hindsight, artistic innovations often appear inevitable. But up to the moment of their conception, they remain in the balance. Inspiration is never guaranteed. So it was for Lichtenstein. The late Forties and Fifties contained several personal milestones. In 1949 he married his first wife, Isabel Wilson, a gallery assistant who later became an interior decorator. Their two sons, David and Mitchell, were born in 1954 and 1956. (David's middle name, Hoyt, was in honour of Lichtenstein's Ohio State teacher.) But, professionally, this was a period of limbo. After he was denied tenure at Ohio State, Lichtenstein moved his family to Cleveland, where he rattled through a succession of short-term jobs. He sold silver jewellery that he made using the lost-wax process. He designed window displays for a department store. He created mosaic tables for Isabel's clients. He hand-painted black-and-white dial markings on volt-and-amp meters for an electrical-instrument company. Eventually he found a position teaching industrial design at the State University of New York at Oswego, where the family moved in 1957.

All the while, he was painting – but with little success. His first solo show in New York, at the Carlebach Gallery in 1951, failed to establish his reputation. During the Fifties, just as he shuttled between different jobs, so he switched between alternative approaches in his art. To begin with, he adopted a faux-naive style and painted Americana subjects such as cowboys on bucking broncos, and the Indian Wars hero General Custer. In 1951 he made two childlike paintings of Washington crossing the Delaware, each an impudent riff upon the grand canvas in the Metropolitan Museum created by Emanuel Leutze a century earlier.

A few pictures of medieval knights followed, as well as many paintings of Native American Indians: *Cherokee Brave, Indian with Tomahawk, Chief Before the Teepee, The Last of the Buffalo, Squaw with Papoose.* The Swiss artist Paul Klee was an important influence, but Picasso's Cubist style was paramount: Lichtenstein recycled a number of Cubist motifs, such as fractured forms, simultaneous viewpoints, overlapping planes of colour and a flattened, two-dimensional sense of space. Years later, when asked about his work during the mid Fifties, Lichtenstein said: 'What I was doing wasn't a play on Cubism, it was Cubism.' He was struggling to forge his own artistic identity.

Disheartened, he changed tack. He made several paintings of mechanical diagrams, engineering blueprints, and clock and gear parts. Then, possibly inspired by a posthumous retrospective for Jackson Pollock at New York's Museum of Modern Art, he went abstract. For a couple of years, between 1958 and 1960, Lichtenstein plugged away in this new mode, building up scribbles, washes and lozenges of pigment into complex compositions that never quite cohered. Among his series from this period are the *Stain* and *Ribbon* paintings. To signal his rejection of his earlier work, he began inscribing canvases with his initials, *rfl*, rather than with his surname. It was only a year or so before *Look Mickey*. But, stylistically, Lichtenstein was as far away from his first Pop work as he had been at the start of the Fifties.

Breakthrough:
'I've hooked a big one!'

There were occasional rumblings of something new: in 1958 he made a series of loose, expressionistic drawings featuring the Walt Disney cartoon characters Bugs Bunny, Mickey Mouse and Donald Duck. Lichtenstein later said that he elaborated this theme in several paintings, which he then destroyed. But the real catalyst came in the spring of 1960, when he took a new job as assistant professor of art at Douglass College at Rutgers University in New Jersey. There, he quickly became close friends with a colleague, the charismatic, pioneering American artist and theorist Allan Kaprow.

Two years earlier Kaprow had published an important essay called 'The Legacy of Jackson Pollock', which suggested that the Abstract Expressionist movement led by Pollock (who had been killed in a car crash in 1956) was a dwindling force. It is noteworthy that Lichtenstein tried to profit from Abstract Expressionism at the very moment when Kaprow was calling the movement creatively bankrupt. Kaprow wanted a new type of art, one inspired by 'the space and objects of our everyday life': 'paint, chairs, food, electric and neon lights, smoke, water, old socks, a dog, movies, a thousand other things that will be discovered by the present generation of artists'. His essay coincided with the first 'Happenings' – spontaneous, theatrical-cum-artistic events involving audience participation that Kaprow and others

such as Jim Dine, Claes Oldenburg and George Segal were staging in revolt against Abstract Expressionism. The first Happening had grown out of a picnic on Segal's New Jersey chicken farm: Kaprow invited the beer-bleary guests to jump through plastic sheets, generate noise in chicken coops and paint a collective canvas. Within months of moving to New Jersey, Lichtenstein had met Oldenburg and Segal, as well as another axis of artists who would be associated with the avant-garde Fluxus movement.

Living in New Jersey also put Lichtenstein within striking distance of New York. Since the Second World War, the Big Apple had become the universally acknowledged capital of world art. The School of New York, impelled by prodigious figures such as Pollock and de Kooning, had triumphed over the School of Paris. Finally Lichtenstein could witness the latest artistic developments at first-hand, rather than relying on minuscule black-and-white reproductions in art magazines. Born in Manhattan, he had spent most of his adult life outside of the metropolis. Now he was back near the centre, feeding off the energy of courageous colleagues and peers. Picasso was no longer his lodestar. That autumn of 1960, he attended a few of Kaprow's experimental Happenings at Rutgers. By the following summer he had painted his first Pop masterpiece, *Look Mickey*. The twelve abstract *Ribbon* paintings that he exhibited at Douglass College in the spring of 1961 suddenly seemed irrelevant, consigned to his prehistory. Lichtenstein's abstract years were over; the Pop era had begun.

If Lichtenstein is the architect of Pop art, then *Look Mickey*, an oil painting measuring 48 by 69 inches, is the movement's foundation stone. Donald Duck and Mickey Mouse are fishing on a jetty. Donald stares into the rippling water below. He is wide-eyed and exultant, because, as it says in the big speech balloon floating above his head, he thinks he's 'hooked a big one'. Unbeknown to him, though, the end of his line has caught the bottom of his sailor's tunic, presumably when he tried to cast his rod by flicking it behind him. He has indeed hooked a

'big one' – his own backside. Like the viewer, Mickey is in on the joke. He stands to the right of the painting, one gloved hand covering his mouth to suppress a snigger at his friend's expense.

According to the art historian James Rondeau, who co-curated the first major Lichtenstein retrospective since the artist's death, *Look Mickey* 'feels like Athena sprung [fully formed] from the head of Zeus'. Here, as if from nowhere, are the hallmarks of Lichtenstein's mature Pop style: a limited palette of even, primary colours (red, yellow and blue); thick, dark outlines; small dots (blue for the 'whites' of Donald's eyes and pinkish-red for Mickey's face) to simulate the representational techniques of cheap commercial printing; the commingling of 'high' and 'low', as everyday, vernacular imagery intrudes upon the ivory tower of fine art. The preparatory pencil marks still visible in places on the canvas would disappear in his subsequent Pop works, but still: it turned out that Lichtenstein, like Donald Duck, had hooked a big one after all – a new way of painting. In this sense, Donald, who tellingly stares at the artist's initials in place of his own reflection in the water, is a surrogate for Lichtenstein – just as Brad would be in *Masterpiece* the following year.

Where did this new style come from? Over the years, conflicting accounts have been given about the origins of *Look Mickey*. The sweetest stories involve Lichtenstein's sons. According to Ivan Karp, who was one of the first people to see the canvas while working at the Leo Castelli Gallery in New York, Lichtenstein said: 'I did some paintings for my kids . . . They asked me if I could paint a cartoon if I had to. And I said I probably could. So I did this giant, oversize cartoon. And they were very impressed by it.'

In a variant of this tale, recorded in 1965 by the artist Hans Richter, who claimed to have heard it from the horse's mouth, Lichtenstein supposedly painted *Look Mickey* after his younger son, Mitchell, returned home from school one day in tears. Asked by his schoolfellows what his father did for a living,

Mitchell replied that he was an Abstract Expressionist. 'Oh,' said the children, 'somebody who paints abstracts because he's no good at drawing.' To prove them wrong, Lichtenstein drew Mitchell 'a great big Mickey Mouse, just like in the comic strips'. Although Lichtenstein later denied this ('I know that's gotten to be a story of how I got into it, it sounds nice but it just isn't true'), maybe it does contain an element of insight. In 1957 Lichtenstein used an opaque projector to trace an image of Mickey Mouse on Mitchell's bedroom wall, just as he would later use an opaque projector to transfer drawings of cartoons on to canvas. Decorating his son's bedroom sparked a creative process that would result in *Look Mickey* four years later.

In interviews, Lichtenstein used to say that a cartoon wrapper inside a packet of bubble gum had inspired *Look Mickey*. We now know this wasn't true – Lichtenstein's source was an illustration from the children's book *Walt Disney's Donald Duck: Lost and Found*, published by Golden Press, Inc. in 1960. So why did he seemingly dissemble? Perhaps he genuinely forgot about the book. Perhaps he half remembered Kaprow's oft-told recollection of seeing *Look Mickey* for the first time, at the end of a conversation about using the cartoons wrapped around bubble gum to teach students about aesthetic principles such as colour, volume and composition. 'Teach them how to make cartoons,' Kaprow had said to Lichtenstein. 'And he smiled at me. A half smile . . . So he flipped through a couple of [canvases] and up came Donald Duck.'

Or perhaps Lichtenstein had in mind a hostile article written by the art critic Max Kozloff in 1962, shortly after the artist's first solo show of Pop paintings at the Leo Castelli Gallery. 'Art galleries are being invaded by the pin-headed and contemptible style of gum-chewers, bobby-soxers, and worse, delinquents,' Kozloff fulminated in *Art International*. As for Lichtenstein's Pop work, it was 'a pretty slap in the face of both philistines and cognoscenti'. In subsequent years, then, when he was asked about *Look Mickey*, it may have amused Lichtenstein to allude slyly to Kozloff's article, antagonizing his critics by confirming

their worst fears. Since the early adopters of Pop art were castigated as 'gum-chewers' (perish the thought!), it was funny to pretend that a bubblegum wrapper had inspired the very first painting in the movement – even though this wasn't true. In a similar fashion, the real joke of *Masterpiece* was that Lichtenstein had the last laugh: philistines and cognoscenti alike soon considered this picture, which had initially appeared like an execrable send-up, first rate.

Still, whatever the reasons for the mystery surrounding the genesis of *Look Mickey*, it pleased people to believe that Lichtenstein had painted it like a conjuror pulling a rabbit out of a hat. That it represented a clean break with Abstract Expressionism was part of the painting's magic. Several recent art historians have challenged this, by stressing its continuity with Lichtenstein's earlier work. He had incorporated text into paintings before, with *Weatherford Surrenders to Jackson* (1953) being one example (though *Look Mickey* is his first painting to contain a speech bubble). As we have seen, he also made a number of drawings of cartoon characters in 1958, as well as a dozen or so related paintings that were subsequently destroyed. Had these transitional works survived, *Look Mickey* might not appear to be so unprecedented. Perhaps Lichtenstein destroyed them deliberately in order to enhance *Look Mickey*'s aura of Immaculate Conception.

Moreover, Kaprow surely deserves some of the credit for Lichtenstein's invention. He once suggested that his interest in everyday objects 'served as a kind of permission note' for Lichtenstein, indicating that 'art doesn't have to look like art'. Referring to Kaprow, as well as to Oldenburg and Dine, Lichtenstein acknowledged this influence during a lecture that he delivered in Japan in 1995: 'In these artists' work there were American advertising and commercial objects and they were trying to escape the influence of Cubism.'

Other artists of the Fifties, such as Jasper Johns and Robert Rauschenberg, had also broken free from the inhibiting influence of Cubism and Abstract Expressionism by incorporating

commonplace objects into their work. 'Painting relates both to art and life,' Rauschenberg wrote in the catalogue for the Museum of Modern Art exhibition *Sixteen Americans* in 1959. 'I try to act in the gap between the two. There is no poor subject. A pair of socks is no less suitable to make a painting than wood, nails, turpentine, oil, and fabric.' So if a pair of socks could make a painting, why not a cartoon from a children's book?

Nonetheless, there was something about *Look Mickey* that appeared unique in the summer of 1961. Finally Lichtenstein had found a way of creating a picture that felt exclusively his own. Yes, *Look Mickey* appeared brash and sacrilegious. 'Even Roy said that when he first started making these paintings, he had to get beyond the level of his own taste,' Dorothy Lichtenstein recalled. 'It didn't look like art.' Maybe not, but – as far as he knew – no one else was doing it. At last, the stumbling uncertainties and false starts of the Fifties were finished. He'd found his 'voice'.

Early Pop: The worst art
in America?

It was unfortunate that this moment of artistic triumph was marred by personal disaster: his marriage to Isabel, who had become an alcoholic, was foundering. Lichtenstein demanded a trial separation in the autumn of 1961 and moved into a studio on Broad Street in New York City. After a failed attempt at reconciliation the following summer, the couple separated permanently in 1965.

But difficulties in his private life did not deter his creativity. As 1961 progressed, Lichtenstein rapidly executed a cycle of canvases in the new Pop style. He painted other well-known cartoon characters such as Popeye and Wimpy. In *Emeralds*, he adapted a panel from the sci-fi comic strip *Buck Rogers*. As well as cartoons, he was drawn to boilerplate advertisements for consumer goods in newspapers, catalogues and magazines. He painted a stove and a washing machine, a yellow turkey on a plate, the twisting black-and-white flex of an electrical cord, vases of flowers, a transistor radio, a pair of canvas sneakers and, in *Roto Broil*, a distinctive multi-purpose cooking appliance that had been popular in the Fifties. The following year he expanded on this domestic theme with several stark, monochrome paintings, such as *Sock*, *Tire*, *The Ring* and *Golf Ball*, as well as canvases of a sticky wedge of cherry pie, a red slab of marbled meat and another transistor

radio (this time, one hanging from the wall by its own leather strap). Anatomizing advertisements promising a suburban lifestyle of plenty and leisure, these paintings formed a composite portrait of the American consumer. Typically, Lichtenstein would simplify his sources and 'island' them against expanses of dots or empty backgrounds, lending the finished paintings a mildly aggressive feel. Their tone is quizzical, bordering on satirical.

Girl with Ball (1961) provides an excellent example of Lichtenstein's early Pop technique. The source for this painting was a black-and-white advertisement for the Mount Airy Lodge resort in the Pocono Mountains of Pennsylvania, which had appeared in the travel section of *The New York Times* in 1961. A shapely young woman wearing a bathing suit, her outstretched arms holding a dark beach ball high above her head, dominates the left of the ad. To the right, rows of chunky script in various typefaces provide details of the resort, and offer a free brochure to help readers plan 'the perfect Pocono honeymoon or vacation'.

To make his painting, Lichtenstein dispensed with all of the text and focused instead on the image of the girl, whom he cropped and subtly transformed. He shortened her arms (which appeared to be unnaturally elongated in the original advertisement), swivelled her gaze so that she stares straight at the viewer, painted the ball red and white to rhyme with her lips and teeth, and added a mass of almost abstract marks to signify her shiny hair fluttering in the breeze. Next, he placed her against a mustard-yellow ground (vaguely redolent of sandy beaches and sunlight), which is broken by an intruding band of white that creeps up from the bottom, limited by an undulating line suggesting mountains or the horizon of a choppy sea. The peaks of this line mirror the points of the girl's bathing suit where the straps pinch the material in place above her breasts.

The subject calls to mind Picasso's magnificent Surrealist painting *Bather with Beach Ball* (1932), in which the artist transformed

his curvaceous young lover Marie-Thérèse Walter into a strange, inflated grey form – part Zeppelin, part elephant – wearing a purple-and-yellow swimsuit, and floating beside the coast. But the spirit of Lichtenstein's predecessor doesn't overshadow *Girl with Ball*, as it would have done in the Fifties. By removing the words from the original advertisement, Lichtenstein drained his painting of distracting narrative detail, creating instead a beautifully balanced image that feels, in the words of one art historian, like 'a marriage of Mondrian and advertising'. The colours are simple (the primaries of red, yellow and blue, plus white); the forms are bold and flat. Supermarket packaging was part of the inspiration for his palette. 'I would look at package labels to see what colours had the most impact on one another,' Lichtenstein said. 'The idea of contrast seemed to be what advertising was into in this case. An advertisement is so intensely impersonal! I enjoyed the idea that anything vaguely red like apples, lips, or hair would get the same red.' As a result, the girl appears artificial, rather than flesh and blood: ball and lips are made of the same plastic material. There is something synthetic, even seedy, about her mouth, which could belong to a blow-up doll. Lichtenstein lays bare what advertising executives already knew: sex sells.

One of the most striking aspects of *Girl with Ball* is the mesh of fine red dots that stipple her flesh like an itchy rash. These dots, which first appeared in *Look Mickey*, quickly became one of Lichtenstein's signature motifs. They mimic a common commercial printing technique known as the 'Ben-Day dot'. In 1879 Benjamin Day had developed an inexpensive technique involving patterns of coloured dots that allowed publishers to mechanically reproduce pictures with a surprising degree of detail and sophistication. Lichtenstein was excited by this visual convention of mass culture, and, starting in 1961, he tried to replicate the effect in his paintings. To begin with, he used a dog-grooming brush with plastic bristles dipped in oil paint. When this didn't work, he drilled holes into a small, thin strip of aluminium to create his own homemade stencil. Eventually, in 1962, he settled upon a satisfactory solution: he painted

dots using as a stencil a large perforated industrial metal screen that he had acquired from a company in New Jersey.

Encouraged by the reception for his Pop work among his new friends at Rutgers, Lichtenstein felt optimistic. The next step was to show his paintings in New York. *Mr Bellamy* (1961) dramatizes his state of mind. A good-looking, square-jawed officer, wearing a splendid white uniform with a single star on each epaulette and rows of medal-ribbons on his chest, walks along a corridor. A thought bubble emerges from his head: 'I am supposed to report to a Mr. Bellamy. I wonder what he's like.' The painting channels Lichtenstein's memories of reporting for duty as a new recruit in the US Army. The plane in the top left may recall his training as a pilot. The caption also offers an in-joke about the New York art world. The previous year, a young art dealer called Richard Bellamy had opened the uptown Green Gallery specializing in contemporary art, with the backing of the arrogant collector Robert Scull, whose booming taxi business had made him rich. *Mr Bellamy*, then, is a wry self-portrait in which Lichtenstein, who was looking for representation, presents artist and dealer in a facetious chain of command.

In the end, Lichtenstein signed with Leo Castelli, an urbane, effortless networker who had been involved with the Abstract Expressionists during the Fifties before setting up his own gallery in 1957. Castelli's 1958 solo exhibition of paintings of targets, numbers and the American flag by an unknown 27-year-old called Jasper Johns was a spectacular success: in an unprecedented move, the art historian Alfred H. Barr, upon seeing the show, decided to buy four works for the collection of New York's Museum of Modern Art, where he was an advisory director. Castelli also represented Robert Rauschenberg, who, in 1964, would become the first American artist to win the Grand Prize at the Venice Biennale.

In the autumn of 1961 Kaprow set up a meeting between Lichtenstein and Ivan Karp, who worked for Castelli. Lichtenstein drove to the gallery on East 77th Street with

five canvases strapped to the roof of his station wagon. Here is Karp's recollection of the encounter:

> I said, 'What are these?' He said, 'Well, Mr Kaprow called about me. I'm Lichtenstein and I wish you'd look at these paintings.' I said to him, 'You really can't do this, you know.' It was just too shocking for words that somebody should celebrate the cartoon and the commercial image like that. And they were cold and blank and bold and overwhelming. So I said, 'Well, look, I'd like Castelli to see these. They're pretty unsettling.' We kept four of them. And then Leo saw them and had his own set of reactions. We both were jolted. We thought, well, let's put them in the racks and we'll take them out again and see how they feel as the days go by. And after a time we agreed it was really an intelligent and original innovation.

Within weeks, Castelli agreed to represent Lichtenstein, who started to consign works for sale to the gallery, including *Emeralds*, *Washing Machine* and *Roto Broil*.

The first work by Lichtenstein that Castelli sold was *I Can See the Whole Room! ... And There's Nobody in It!*, in which a man pushes aside a peephole cover with one finger and peers into a dark space. (Fifty years later, the picture went for $43.2 million (£26.8 million) at an auction in New York.) The painting's point of view is unexpected: Lichtenstein positions his audience inside the room so that, aside from a speech bubble containing the words of the title at the top of the canvas, all we see is an expanse of black interrupted by a circle in which the man's face and finger appear against a snatch of yellow. According to the art historian Michael Lobel, the man is a stand-in for Lichtenstein, eyeballing roughly contemporary abstract artists such as Ad Reinhardt and Frank Stella, who worked in black. If true, the message of the painting is combative: the upstart Pop artist surveys the 'room' of abstraction, and finds it empty.

Later that year, a shy, listless commercial illustrator called Andy Warhol turned up at Castelli's gallery to buy a work of art by Jasper Johns (he left with a drawing of a light bulb). While talking to Karp, he spotted Lichtenstein's *Girl with Ball*. 'Oh!' he said in astonishment, before inviting Karp to his four-storey townhouse on Lexington Avenue to see his own paintings on similar themes, including *Superman*, *Saturday's Popeye*, *Dick Tracy* and *Batman*. Neither Warhol nor Lichtenstein, who visited the Lexington Avenue studio with Karp, was aware of the other's work – yet both were painting cartoons, advertisements and commercial illustrations at exactly the same time. Castelli declined to represent Warhol, because he was worried that Warhol's work was too similar to that of Lichtenstein, who was already on the gallery's books. But, as Karp immediately recognized, 'Something very strange was going on in the art world.' Pop art had arrived.

Lichtenstein's first solo show at Leo Castelli opened in February 1962. Although it was a sell-out, with prices ranging from $400 to $1,200, the exhibition wasn't entirely a success. Art critics were dumbfounded by the new Pop work of Lichtenstein, Warhol and others including Oldenburg and James Rosenquist. Dore Ashton, a keen proponent of Abstract Expressionism, wrote a particularly abusive review in 1962: 'I am interested in Lichtenstein as I would be interested in a man who builds palaces with matchsticks, or makes scrapbooks of cigar wrappers. His "art" has the same folk originality, the same doggedness, the same uniformity.' A couple of years later *Life* magazine published an article about Lichtenstein underneath the headline 'Is He the Worst Artist in the US?' (The title, which received the blessing of Lichtenstein, who was no stranger to provocation and irony, played upon a famous profile of Jackson Pollock, published by *Life* in 1949, which had posed the question: 'Is He the Greatest Living Painter in the United States?')

Writing about Lichtenstein's retrospective at the Guggenheim Museum in 1969, Max Kozloff (who had been so dismissive of

people who liked Pop art in *Art International* seven years earlier) recalled the 'acid shock' of seeing Lichtenstein's work for the first time in 1962: 'To drink in those images was like glugging a quart of quinine water followed by a Listerine chaser.' Today, time and familiarity have neutralized the 'acid shock' of Lichtenstein's Pop paintings. As the artist said: 'New things always seem much more startling than they seem twenty years later or when they have sunk into the history of art.' In order to understand the importance of his Pop canvases, therefore, we need to reconstruct their original sharpness.

Battleground: 'The things that I have apparently parodied I actually admire'

One way of thinking about Lichtenstein's early Pop work is as an assault on abstract art, which had dominated the Fifties. Take one of the first pictures that he painted after *Look Mickey*: *Popeye* (1961), in which the Herculean sailor-man, pumped up with spinach, wields his dumb-bell forearms to knock out the bearded villain Bluto. According to an ingenious reading, the painting dramatizes an inter-generational struggle in which victorious Pop art, represented by the appropriately named Popeye, smacks Abstract Expressionism to the floor. 'I chose the scene,' said Lichtenstein, 'because it reminded me of [Honoré] Daumier's *Battle of the Schools*.' (This was a famous caricature of opposing factions within nineteenth-century French art.) The brutish, growling character of Bluto offered a neat parody of the bullying Abstract Expressionists, who were famous for boozing and brawling in Greenwich Village's Cedar Tavern in the early Fifties.

Popeye's knockout blow enacted the 'punchy' impact of the new type of Pop art. In addition, Lichtenstein's fastidious application of paint reproached the default mode of the Abstract Expressionists, who were known for spontaneous brushwork that supposedly summoned psychological and emotional turmoil on to the canvas. For the Abstract Expressionists, every painterly splatter was an index of their tortured

souls; for Lichtenstein, however, painting was a calculated, disciplined affair. In 1962 he started to use turpentine-soluble Magna acrylic paints, as well as oils. This afforded him greater flexibility to edit as he went along, since he could wipe away unwanted Magna using turpentine without harming the layers underneath (as long as those layers had already been protected with alcohol-based varnish). 'I want my painting to look as if it has been programmed,' Lichtenstein said. 'I want to hide the record of my hand.'

Several paintings from this period mock Abstract Expressionist improvisation. In *Washing Machine* (1961), for instance, swirling yellow detergent lampoons the drips of painters such as Pollock. So do the turbulent waters of *Drowning Girl*, even if their primary art-historical reference is to the famous *Great Wave* woodblock print by the nineteenth-century Japanese artist Hokusai. For Lichtenstein, impulsive brushwork, which had proved so crucial for artists during the Fifties, had become a mannerism – something that people did without thinking when they wanted to paint like 'fine' artists. In short, Lichtenstein recognized that Abstract Expressionism had ossified into cliché. This is why he began his *Brushstrokes* series in the autumn of 1965. In the first canvas in the sequence, a hand holding a paintbrush, visible in the lower-left corner, has just laid thick, matt stripes and splodges of blood-red paint over a field of blue dots in the background. In Lichtenstein's subsequent *Brushstrokes* paintings, such as *Little Big Painting* (1965), hands and brushes disappear, but painted marks remain, seemingly spontaneous but actually rendered in a dispassionate fashion. The series is animated by the classic Lichtenstein opposition of 'hot' content versus 'cool' style. 'It's taking something that originally was supposed to mean immediacy and I'm tediously drawing something that looks like a brushstroke,' Lichtenstein explained. The wildness of Abstract Expressionism had been tamed.

Lichtenstein's attitude towards abstraction, though, was more complex than straightforward raillery. The horizontal

bands of red and yellow in the background of *Popeye* could have been painted by contemporary abstract artists such as Kenneth Noland and Morris Louis, who were being touted as the heirs to the Abstract Expressionists by a number of influential critics. Moreover, take a closer look at the discarded can of spinach behind Popeye. The only visible letters spell out the word SPIN. In 1950 Lichtenstein had designed a rotating easel that allowed him to work on paintings sideways and upside down. He also worked with mirrors, so that he could examine his canvases back to front, in order to abstract their subject matter and to achieve the kind of compositional unity that Sherman had taught at Ohio State. In this light, perhaps we should understand the text in *Popeye* – SPIN – as a command to rotate the painting in our mind's eye, until it's the wrong way up; the curving marks describing the arc of Popeye's left fist point the way. The message? Don't fixate on the 'low' figurative subject and forget that the painting also engages with the 'high' rhetoric of abstract art. Lichtenstein is saying that, on one level, *Popeye* works as a carefully constructed sequence of forms and colours that don't 'mean' anything at all – just like abstract paintings by Noland and Louis.

When Lichtenstein painted *Popeye*, it wasn't clear whether abstract painting or Pop art would win out. Effectively he was saying: anything abstract artists can do, I can do just as well. The painting, then, is much more refined than it may look. As well as alluding to a nineteenth-century lithograph by Daumier, it thumbs its nose at Modernist painting while holding on to that same tradition. As Lichtenstein said in 1964: 'The things that I have apparently parodied I actually admire.'

My favourite example of Lichtenstein's having-his-cake-and-eating-it relationship with Modernism and abstraction is a series of three paintings of exercise books from 1964 and 1965. The first in the sequence, *Compositions I*, is typical. It represents a notebook cover decorated with a marbled design in black and white, not dissimilar to the pattern describing the pleasure-seeker's

glossy hair in *Girl with Ball*. The edges of the cover precisely match the limits of the canvas. To the left, a black stripe runs down the length of the picture, suggesting the binding that would hold together the notebook in reality. In the centre, a large white panel containing text is superimposed upon the swarming, leaf-like black shapes. This panel contains the word COMPOSITIONS in an elegant, flourishing script. Beneath that, the smaller word NAME precedes three blank lines where the notebook's owner would ordinarily inscribe their identity. Underneath that, in even tinier type, we read the slogan MADE IN U.S.A.

Like *Popeye*, *Compositions I* is a brilliant example of a painting that initially looks like nothing much, but is actually full of riddling nuance and irony. For starters, the churning marks of the cover's pattern burlesque all-over Abstract Expressionist painting: while these forms may appear involuntary (and therefore somehow 'authentic'), there is nothing uncontrolled about the way that Lichtenstein applied Magna paint to the canvas.

Next, because there is a direct correspondence between the shape of the notebook and the dimensions of the canvas, the picture is presented by Lichtenstein as an 'object' – in the manner of the famous *Flag* paintings shown by Jasper Johns at the Leo Castelli Gallery in 1958. This is another piece of sport. Johns's *Flag* series had excited the art world because it so effectively blurred the boundary between artifice and reality: as one critic wrote at the time, 'Is this a flag or a painting?' *Compositions I* is almost six feet tall, however, so nobody in their right mind could mistake it for a real notebook; Lichtenstein thus uses its size to undermine Johns's invention. Moreover, supersizing a commonplace object was self-consciously ridiculous – as if Lichtenstein were responding to those critics who had attacked him for banality: 'You think my work is dumb? Well, how about this!'

Perhaps, though, the best way to understand *Compositions I* is as a kind of self-portrait. Lichtenstein used to store source

material for his pictures in cheap notebooks similar to the one in the painting: whenever he spotted an illustration, advertisement or panel in a comic strip that he thought had potential, he would cut it out and carefully paste it into one of his jotters. (When he began a series of late nudes in the Nineties, shortly before his death, he turned to this archive of comic-book clippings for inspiration.)

What we are looking at, then, is the source-book of his imagination. During the Fifties, Lichtenstein had been plagued by the bedevilling question of what to paint. *Compositions I* is his blunt, deadpan response to this conundrum. Nothing about it is tortured or yearning, as Abstract Expressionist compositions tended to be. Instead, Lichtenstein offers matter-of-fact reality, writ extra-large.

Yet, much like his explicit *Self-Portrait* of 1978, which I will discuss later, *Compositions I* gives little away. There is no signature – and, just to emphasize this fact, the lines that follow the word NAME are empty. The Rorschach test of the cover's black-and-white pattern yields nothing. As its subject matter explicitly suggests, *Compositions I* is a closed book.

Of course, this befits an artist known for his reserve. But it also brings us close to the essential paradox driving Lichtenstein's art. Lichtenstein's Pop look is one of the most recognizable styles in twentieth-century art. The primary colours, the outlines, the dots: it doesn't matter what he painted, for we always sense his hand. Yet everything about his Pop style was based upon the elimination of personality. His paintings, though handmade, aped the impersonal appearance of mechanically reproduced imagery. As Ivan Karp put it, they look 'cold and blank'.

Americana: 'We're not living in the world of Impressionist painting'

For me, one of the most pregnant details of *Compositions I* is its generic tag MADE IN U.S.A. Remember how Lichtenstein simplified his source for *Girl with Ball* by removing the text? Here he's doing something similar. Lichtenstein owned many notebooks that looked like the cover he painted in *Compositions I* – but no two were exactly the same. Usually, his notebooks were emblazoned with a brand name (e.g., 'Boorum & Pease'). The label might contain additional information, such as the book's price ('39¢'), number of pages (or 'leaves'), dimensions or the manufacturer's address ('Roaring Spring Blank Book Co., Roaring Spring, Pa.'). But when it came to constructing his *Compositions* paintings, Lichtenstein deliberately left out most of this material (though *Compositions II* does contain a price – '59¢' – making for an ironic contrast with the painting's actual price tag, which was considerably higher). It is as though he were trying to tune out the crackle and white noise of modern life to concentrate instead on its underlying melody. In *Compositions I*, Lichtenstein doesn't simply replicate a notebook lying about in his studio; he gives us the Platonic ideal of a notebook, if you will. And, appropriately enough, Lichtenstein's 'Ur-Notebook' wasn't manufactured somewhere specific, such as Massachusetts or Pennsylvania. No, it was made – generically – in the USA.

This detail is important in part because it sheds light upon early Sixties Pop in general. Pop art was a realist mode. But American Pop artists didn't paint any old reality as a backlash against abstraction: they chose to depict America. Warhol painted Coca-Cola bottles, dollar bills and Campbell's soup cans. Ed Ruscha took photographs of gasoline stations along Route 66. Tom Wesselmann introduced milkshakes and ice-cream sundaes into his series of *Great American Nudes*. Rosenquist painted Fords and Chevrolets and President Kennedy's beaming face. The art critic Peter Schjeldahl recently defined 'the deep programme of Pop art' as 'reconciling Americans to American culture, as it happened to be'.

Thanks to an unprecedented post-war economic boom, America was more prosperous than ever before, and the Pop artists recorded this prosperity. Sometimes they were critical of capitalist consumerism. Often they colluded with it. Occasionally they regarded it with a non-committal shrug. But, whatever their stance, they all wanted to stop cap-doffing and cringing before European culture, and to concentrate instead on something home-grown and rampantly successful.

Lichtenstein, who had been painting Americana since the start of the Fifties (his proto-Pop lithograph, *Ten Dollar Bill*, dates from 1956), was well placed to anticipate this development. As we have seen, painting reality offered a way forward, since it released him from the shackles of abstraction that had imprisoned second-generation Abstract Expressionists during the Fifties. Painting American reality, though, was especially exciting, since it allowed him to leap clear, once and for all, of the basilisk stare of the masters of the School of Paris. 'It's really the art we have around us,' he once said. 'We're not living in the world of Impressionist painting . . . Our architecture is not van der Rohe, it's really McDonald's, or little boxes.'

The revelation of *Look Mickey* was that he could channel the vitality of popular culture; he could accept, as he put it in 1965, 'the full force of the tremendous traffic involved in highly industrialized civilization'. Suddenly it was okay to make ostensibly

vulgar pictures of everyday things such as comics, advertisements and bubblegum wrappers – precisely because they existed in opposition to the rarefied culture so prized by the Abstract Expressionists and the Europeans. This is why, in his Japanese lecture of 1995, Lichtenstein stressed the influence of artists such as Kaprow, Oldenburg and Dine, because their work contained 'a tendency toward American or vernacular commercial representations of objects'. In the same breath, he expanded his list of influences to include 'Stuart Davis, whose images incorporated gas station signs and other non-Parisian and definitely American subjects'. MADE IN U.S.A., then, is the mantra of Lichtenstein's Pop art, which asserted its identity by letting the world know that it was emphatically not made in Paris.

Lichtenstein™: Pop artist or copycat?

Yet, while Lichtenstein's Pop paintings drew upon reality, with a few rare early exceptions, such as *Roto Broil*, his visions were mostly free of trademarks and brand names – unlike those of many of his contemporaries (think of Warhol's *210 Coca-Cola Bottles* and *Brillo Boxes*, or Ruscha's *Standard Station*). 'There's something about brand names that I don't care for,' Lichtenstein said. This is why he painted female hands obscuring labels on packaging in *Washing Machine* and *Spray* (1962). This is why there are no logos in *Golf Ball* or *Tire*. This is why he replaced recognizable cartoon characters such as Donald Duck and Mickey Mouse with anonymous men and women from unfamiliar comic strips. Other Pop artists painted superheroes such as Batman; Lichtenstein preferred expressionless men with generic names like Brad.

Why was this? The answer is complicated, but it touches upon a fundamental misconception about Lichtenstein's art. Lichtenstein wasn't interested simply in presenting reality; he wanted to paint *representations* of reality.

To begin with, this was not widely understood. When Lichtenstein first started showing his Pop work, people assumed that he was using comic strips in the same way that artists had incorporated modern life into their work earlier in the twentieth century. Picasso and Braque, for instance, created Cubist

collages out of disparate odds and ends such as newsprint, torn-off advertisements, playing cards, scraps of wallpaper and loops of rope. Sixties onlookers thought of Lichtenstein's cartoon paintings as found objects – a little like Marcel Duchamp's mass-produced ready-mades, which included the urinal that the subversive French-American artist had famously signed 'R. Mutt', as well as a bicycle wheel, a snow shovel and a bottle rack. As a result, Lichtenstein was accused not only of banality but also of plagiarism: people said that he was ripping off other people's artwork.

One unfortunate episode offers a good example of this response. In the early Sixties, as well as producing paintings of consumer goods and cartoons, Lichtenstein embarked on a series of pastiches of famous modern artists including Picasso, Mondrian and Cézanne. In 1962, for instance, he painted *Femme au chapeau*, his first explicit appropriation of Picasso. Lichtenstein referred to these pictures as 'idiot paintings', since their dots, outlines and primary colours shouted down the subtlety of the originals like a half-witted loudmouth confronting a philosopher. In 1963, however, he ran into trouble when an art historian called Erle Loran accused him of plagiarizing diagrams of portraits by Cézanne, which Loran had designed twenty years earlier in order to elucidate the compositional techniques employed by the Post-Impressionist French painter. In his *Art News* article 'Pop Artists or Copy Cats?' Loran argued that Lichtenstein wasn't a proper artist, because his work contained no element of 'transformation'. There is no doubt that Lichtenstein based his Magna painting *Portrait of Madame Cézanne* (1962) upon one of Loran's diagrams. Moreover, while we have seen that *Girl with Ball* or *Compositions I* both deviated from their sources in important ways, in the case of *Portrait of Madame Cézanne*, the transformation was less clear. Based upon a portrait by Cézanne of his wife, Loran's diagram presented a silhouette covered with arrows and dotted lines, as well as capital letters referring to an extraneous key; Lichtenstein's *Portrait of Madame Cézanne* copied Loran's diagram almost exactly.

Some scholars suggest that Lichtenstein was making a joke at Loran's expense – satirizing the academic impulse to reduce something as complex as a painting by Cézanne to a schematic design. I'm not so sure. I think that Lichtenstein was attracted to Loran's diagram because it seemed like the quintessential Pop ready-made, not unrelated to Warhol's 1962 *Do It Yourself* series of paint-by-numbers art, which sent up the idea of the modern artist as a solitary genius toiling away in a freezing downtown loft. *Portrait of Madame Cézanne* deconstructs Lichtenstein's 'idiot paintings' of modern masters. It offers a joke about Pop's capacity to transform any image – be it from 'high' or 'low' culture – into the same flattened, graphic forms.

But, either way, even a cursory understanding of Lichtenstein's working methods reveals that he didn't just plagiarize images. Typically, he began by making a drawing in pencil or coloured crayons of a source that grabbed his attention. Sometimes – for instance, in the case of a few *War* paintings – he synthesized several sources into a single image, taking a scrap of dialogue from one panel, adding a face from another, a gun barrel or fighter plane from a third, and so on. Using an opaque projector, he would then transfer his sketch on to a canvas by tracing it in pencil, enlarging it in the process, and further tweaking its composition and design. Only then would he start to paint, sometimes with the help of assistants, adding the black outlines at the end. As a number of art historians have pointed out, Lichtenstein's paintings, which appear so mechanical, were strikingly handmade. His decisions were considered, 'artistic', every step along the way.

What does this tell us? For me, it's a reminder that above all Lichtenstein was a formalist whose presiding interest was style. 'What I do is form,' he said in 1963.

> The comic strip is not formed in the sense I'm using the word; the comics have shapes, but there has been no effort to make them intensely unified. The purpose is different, one intends to depict and I intend to unify. And my work is actually

different from comic strips in that every mark is really in a different place, however slight the difference seems to some. This difference is often not great, but it is crucial.

Here he is again, even earlier, in 1962:

> I think many people miss the central tendency of the work ... I don't care what, say, a cup of coffee looks like. I only care about how it's drawn, and what, through the additions of various commercial artists, all through the years, it has come to be, and what symbol has evolved through both the expedience of the working of the commercial artists and their bad drawing, and the reproduction machinery that has gotten this image of a coffee, for instance, to look like through the years. So it's only the depicted image, the crystallized symbol that has arrived ... We have a mental image of a sort of the commercialized coffee cup. It's that particular image that [I'm] interested in depicting. I'm never drawing the object itself. I'm only drawing a depiction of the object – a kind of crystallized symbol of it.

It didn't matter whether Lichtenstein was anatomizing the clichés used by commercial artists to depict a cup of coffee, as he did when he painted *Cup of Coffee* in 1961, with its oddly stiff double helix that we read as 'steam' even though it looks nothing like vapour; or interrogating the increasingly hackneyed 'spontaneous' marks of the Abstract Expressionists, as he did in so many of his Pop paintings, including the *Brushstrokes* series of 1965–71: in both examples, he wasn't painting a 'thing' (coffee cup, abstract brushstroke) – he was painting a visual code used by other artists to paint a thing. 'Of course visible brushstrokes in a painting convey a sense of grand gesture,' Lichtenstein said in 1995, referring to *Brushstrokes*. 'But in my hands, the brushstroke becomes a depiction of a grand gesture.' He didn't want to paint objects for the sake of painting objects – he wanted to paint style.

This is why he didn't care for brand names. Following *Look Mickey*, Lichtenstein quickly worked out that if he dispensed with familiar cartoon characters and logos, and kept the things that he was painting as standardized as possible, then he might – just might – be able to create an artistic style that would feel original. He could replace the brand names of American consumer culture with his own artistic trademark: Lichtenstein™. This is why the art critic Carter Ratcliff coined the term 'Lichtensteinize' to describe the artist's method of imprinting his own style upon a subject. His 'idiot' versions of Mondrian and Picasso aren't as moronic as they seem: rather, the Pop artist is vanquishing the potentially overwhelming influence of his forebears by 'Lichtensteinizing' them.

Stereotypes: The most clichéd artist who ever lived

Why did he want to Lichtensteinize the world? We have seen that Lichtenstein experienced a crisis in confidence as an artist during the Fifties. On the one hand, he was unable to break free from the powerful influence of Picasso and the Abstract Expressionists. On the other, the barrage of mechanically reproduced imagery unleashed by the media risked rendering painting irrelevant altogether. To escape this double bind, he tried out various approaches – but he always felt that he was imitating a visual language constructed by someone else. It became impossible for him to put down paint without feeling as though his marks were derivative and second rate. His solution to this problem was remarkable. Since everything that he was painting felt like a cliché, he decided to make clichés the form and subject of his work.

If Lichtenstein could make his paintings look as mechanical and generic as possible – if, in the words of Ivan Karp, he could make them appear cold and blank – perhaps, paradoxically, he could at last achieve something original. And in order to get this look – in order to efface the kind of supposedly eloquent painterly gesture that was synonymous with artistic authenticity and identity for the Abstract Expressionists – Lichtenstein turned to the most inauthentic, hackneyed and stereotyped form of visual

culture that he could find: mechanically reproduced mass media. He found a saviour in Donald Duck.

Clichés – usually so deadening in a painter's work – became the lifeblood of Lichtenstein's art. In 1964, for instance, he painted *Temple of Apollo*, based on a postcard of a Greek temple that he'd spotted in a coffee shop. As the artist Donald Judd noted in his review of Lichtenstein's third one-person show with Leo Castelli, in which *Temple of Apollo* was shown in 1964: 'No one knows anything about Greek temples and everyone agrees they're great. Lichtenstein is working with this passive appreciation and opinion.'

Architectural clichés also inspired a little-known series of thirty *Entablature* paintings in the Seventies. Lichtenstein based these paintings on black-and-white photographs of over-looked neoclassical details such as architraves, cornices and friezes on banks and other institutional buildings along Wall Street near his studio in Lower Manhattan. Why did Greco-Roman forms appear on so many buildings in the late nineteenth and early twentieth centuries? Surely all these details, which once served a purpose in antiquity, had become decorative baloney? Were the buildings' architects even aware of their significance? Or did they use them simply as a thoughtless shorthand for 'the establishment', in order to give their designs the appearance of importance? And if they had become emptied of meaning, could Lichtenstein reanimate them? He certainly gave it his best shot: the stripped-back, repetitive compositions of the *Entablature* paintings bear a striking resemblance to Minimalist art.

Visual forms that had decayed into stereotype always aroused Lichtenstein's curiosity. 'He pays homage to the clichés of a visual argot ponied by all sorts of uncomprehending middlemen, whether they be art directors, product designers, or commercial illustrators,' wrote Max Kozloff in his 1969 review of the artist's retrospective at the Guggenheim. By this point, Kozloff had come round to Lichtenstein's art.

Something similar could be said about Lichtenstein's later appropriations of contemporary art and art history. In his *Modern* pictures of 1966–71, Lichtenstein analysed unfashionable Art Deco style, which he considered 'Cubism for the home'. Lichtenstein also made *Mirror* paintings, which poked fun at voguish contemporary abstract painters such as Ellsworth Kelly, and a set of works called *Artist's Studio*, which was indebted to Matisse. In the late Seventies he experimented with the Surrealist imagery of Salvador Dalí, Max Ernst and René Magritte. In a series of bronze sculptures of the Eighties and Nineties, he used clichéd forms to represent *Archaic*, *Amerind* and *Modern* figures and heads. Above all, Lichtenstein painted many works inspired by Picasso, whom he quoted more often than any other artist. Long before appropriation became a popular strategy among Post-Modern artists such as Richard Prince and Sherrie Levine, Lichtenstein was remoulding other people's imagery. In all of these works, Lichtenstein identified the tics associated with particular artists, movements and styles, and offered them up like logos. Many of his works are about the bare minimum required to transmit the essence of a style or visual code.

Lichtenstein's lifelong interest in form was stimulated by his discoveries in the early Sixties. After examining comic books, cheap illustrations and newspaper advertisements in order to imitate their 'look', he became obsessed with how the artists behind them borrowed and elaborated particular motifs, until those same motifs tipped over into cliché. He began to scrutinize the mechanisms that aided visual communication. He loved to make connections between apparently unrelated images and ideas. 'There is a relationship between cartooning and people like Miró and Picasso which may not be understood by the cartoonist, but it definitely is related even in the early Disney,' he said.

He understood that mass media had accelerated the communication of visual ideas so that they were conveyed more quickly than ever before. He sensed that if he could capture

this process in action, he would be doing something new. Like a scientist codifying the human genome, he wanted to dissect the hitherto overlooked codes, symbols and signs that underpin the mechanically reproduced imagery we encounter every day.

There are countless examples of this in his work. Part of the subject of *Popeye*, for instance, is the odd pictorial vocabulary of lines and stars – cartoon code for motion and activity. 'These signs for movement, which do not exist in nature, were of great interest to me,' he later said. 'There are certain marks, like these, that I am fond of using because they have no basis in reality, only in ideas.'

Similar marks crop up in two versions of a picture called *In the Car* (1963), where near-identical sets of parallel lines represent different things. When applied diagonally to the right of the composition, they stand for the reflective glass of the windscreen. But when positioned horizontally on top of the blonde woman wearing a leopard-print coat to the left, they mean something else: the sensation of speed. When you stop to think about it, this comic-book convention is very strange: why do we 'read' a single, simple artificial sign in different ways?

Lichtenstein loved visual ambiguity like this, when one mark could mean many things. Often he emphasized ambiguity and artificiality by pushing representational marks to the point of abstraction. Thus, the flickering black-and-white patterns in, say, *Tire*, *Golf Ball* or *Large Spool* (1963) resemble the optical illusions of abstract Op art. The idea for his fifty *Mirror* paintings came from sales catalogues and trade brochures in which commercial artists used diagonal lines and slash marks to solve the tricky problem of how to represent objects that always reflect something else. 'We have come to accept these symbols,' Lichtenstein noted. He might have added: why?

According to Dorothy Lichtenstein, he even thought about some of the text in the speech bubbles of his *War* and *Romance* paintings 'as just marks, abstract marks, to balance the painting'. The example she gave was 1962's *Eddie Diptych*. In this

two-part, hinged painting, the left-hand canvas contains nothing but a sizeable slab of black-and-white text about an obsession with 'Eddie', offsetting the larger image to the right, which depicts a truculent blonde girl rebuffing her mother. In effect, the left-hand canvas functions as a thought bubble, providing the girl's interior monologue, while the text in the right-hand painting records her audible dialogue with her mother. This is why Dorothy Lichtenstein's remark is so startling: it suggests that the artist didn't care about the subtle relationship between the different blocks of text in the painting. Instead, words for Lichtenstein were verbiage. He was interested in them because they looked good: their appearance trumped their meaning. This explains the recurrence in his paintings of nonsensical sound effects – clumps of garbled letters that have formal properties such as size and colour, but no semantic function.

Ultimately, Lichtenstein revealed an essential truth about the modern world: that mass culture has a levelling effect. In 1981 he described his work as 'a comment on the fact that we see everything second or third hand'. The British artist Richard Hamilton, who anticipated Pop art during the Fifties, put it very well. 'What Lichtenstein makes perfectly clear,' he wrote in 1968, 'is that all his subjects are made as one before he touches them. Parthenon, Picasso or Polynesian maiden are reduced to the same kind of cliché by the syntax of print: reproducing a Lichtenstein is like throwing a fish back into water.'

The Pop approach that Lichtenstein pioneered has been exceptionally influential. Successful contemporary artists such as Michael Craig-Martin, Jeff Koons and Julian Opie are indebted to Lichtenstein. 'If you look at people who came out of Duchamp and Picasso, in terms of appropriation – using ready-made images and materials – things were more dry and cerebral,' Koons said in 2008. 'Roy and Andy [Warhol] made it so that information . . . could be kind of sexual, sensual, and charged. And so they really changed the whole landscape of contemporary art through that.'

Artists from a younger generation owe something to Lichtenstein too. In *Super Mario Clouds* (2002), for instance, the New York artist Cory Arcangel hacked a famous Nintendo computer game, so that all that remained of the graphics were pixelated white clouds jolting across a blue background. Almost four decades earlier, Lichtenstein had done something similar. In his series *Landscapes*, he painted the sort of generic scenery that forms the backdrop to countless comic books (see, for example, *Sunrise* (1965)). In doing so, he reinvigorated a time-honoured genre, updating landscape painting for the modern world.

Lichtenstein was a genius because he recognized that 'high' and 'low' culture were much more enmeshed than people had thought. This is the underlying meaning of his paintings. Take the memorable oil painting *Golf Ball*, for instance. Lichtenstein expanded a black-and-white newspaper advertisement showing a golf ball in close-up so that it filled an entire canvas, measuring 32 by 32 inches. The effect is otherworldly: the dimples that pock the ball's surface are reminiscent of craters on the moon – even if, strictly speaking, they are a touch too regular to resemble lunar terrain. Lichtenstein, however, had another reference in mind: *Golf Ball* alludes to the so-called *Plus and Minus* series of monochrome abstractions that Mondrian painted between 1914 and 1918. How could these things ever be related, except in the mind of someone who wanted to do away with distinctions between 'high' and 'low'? With Lichtenstein, everything was fair game as a potential source for art. In fact, the more clichéd something was, the better. You could even say that Lichtenstein was the most clichéd artist who ever lived. But it was the way he presented clichés that made him great.

Invisible Man: A portrait
of the artist

I want to finish by considering a self-portrait that Lichtenstein painted in 1978. This was unusual: 'I've never done a self-portrait,' he'd announced three years earlier. The great self-portraits of the past promised revelation about their makers; Lichtenstein's did not. It looks like a self-portrait by the Invisible Man. Instead of his face, we see a rectangle decorated with wavy blocks of black and cobalt-blue dots, alongside bands of duck-egg blue, yellow and green. We know from the series of related *Mirror* paintings that Lichtenstein worked on between 1969 and 1972 that this shape is a semi-abstract approximation of a looking glass with a bevelled edge. If you hadn't seen Lichtenstein's earlier work, though, this would not be readily apparent.

Underneath the mirror is an empty white T-shirt with a blank label inside the neck. A block of primrose-yellow lightness occupies an area behind the mirror and T-shirt to the left. To the right, the sparseness of the rest of the painting is disrupted by a bold pattern of diagonal black lines that wriggle and refuse to lie still when the eye rests on them, like one of Bridget Riley's black-and-white paintings of the Sixties. Presumably these diagonal lines, which allude to the Op art boom of which Riley was a part, also represent shadows in the back of the room.

The paradox of Lichtenstein's self-portrait is that it is both anonymous and full of identity. There is nobody there – no eyes to offer a window on to the soul, no wrinkles bespeaking crumpled experience. Yet at once we guess that it is a painting by Lichtenstein. Why? Because its style is so distinctive: the dots, the stripes (an innovation from the Seventies), the simple colours, the black outlines – it couldn't have been painted by anybody else. If it had been, it would still read as a pastiche of a painting by Lichtenstein. What makes it a self-portrait isn't the stuff represented in the painting (a generic T-shirt and a void mirror, both of which could refer to anyone), but the manner in which the objects are depicted – i.e., the painting's style. A statement about anonymity contains an assertive announcement of identity. As in the *War* and *Romance* paintings, form and content are opposed.

Anonymity versus identity: this is the matrix of Lichtenstein's art. We could even define the double-think paradox of his paintings as 'Lichtenstein's Law': when an artist creates an unmistakable style by appearing to vanish into thin air.

Ten Essential Works by Lichtenstein in Public Collections

1. *Look Mickey* (1961) – National Gallery of Art, Washington
2. *Girl with Ball* (1961) – Museum of Modern Art, New York
3. *Drowning Girl* (1963) – Museum of Modern Art, New York
4. *Whaam!* (1963) – Tate Gallery, London
5. *As I Opened Fire* (1964) – Stedelijk Museum, Amsterdam
6. *Compositions I* (1964) – MMK Museum für Moderne Kunst, Frankfurt am Main
7. *Little Big Painting* (1965) – Whitney Museum of American Art, New York
8. *Rouen Cathedral, Set 5* (1969) – San Francisco Museum of Modern Art
9. *Mirror #3 (Six Panels)* (1971) – Art Institute of Chicago
10. *Artist's Studio 'Look Mickey'* (1973) – Walker Art Center, Minneapolis

Acknowledgements

I could not have written this book without recourse to the wealth of original and intelligent scholarship about Lichtenstein and Pop art that has accrued over the past half century. My brief bibliography acknowledges only a tiny fraction of the thousands of important articles and books about Lichtenstein published by art historians over the years; I have listed publications, several of which were issued in the last decade, that I found especially authoritative, succinct, clear-sighted and, crucially, readable. Since my short book is designed for the general reader, I have deliberately excised the usual paraphernalia of scholarship, such as footnotes. Where I have borrowed the elegant ideas of others, I have usually named their authors; the art historian who described *Girl with Ball* (1961) as 'a marriage of Mondrian and advertising' was Bradford R. Collins.

I am particularly grateful to James Rondeau, the Frances and Thomas Dittmer Chair and Curator in the Art Institute of Chicago's Department of Contemporary Art, who, in the summer of 2012, generously gave me a tour of the magnificent survey of Lichtenstein's art that he had organized in collaboration with Tate Modern. With more than 160 works, this was the most extensive retrospective since Lichtenstein's solo exhibition at the Solomon R. Guggenheim Museum in 1993. I am also grateful for the insights and enthusiasm offered by Letty Lou Eisenhauer,

who lived with Lichtenstein in New York City for several years after his marriage to Isabel Wilson had broken down in the early Sixties, and with whom I corresponded via email while researching this book.

Above all, though, I am indebted to the Roy Lichtenstein Foundation, which kindly agreed to check the accuracy of my text. Image Duplicator (www.imageduplicator.com), the Foundation's free online search engine, is an indispensable resource for anyone curious about Lichtenstein's work, from the non-specialist with a passing, casual interest to acclaimed art historians steeped in the subject. The site contains a definitive, decade-by-decade chronology of Lichtenstein's life, as well as images of almost all of his output, arranged alphabetically by title, year by year. When you click on a particular image, as well as information about its date, dimensions, medium and the collection in which it can be found, you are directed to further relevant visual material, such as studies or sources in newspapers and comic strips. In the case of *Look Mickey* (1961), for instance, we see the page of *Walt Disney's Donald Duck: Lost and Found*, published by Golden Press, Inc. in 1960, which was the painting's source. Even the ephemeral postcard that inspired *Temple of Apollo* (1964) is reproduced: typically Lichtenstein removed its text, in order to create a vision of generic Grecian ruins, rather than a record of the specific site at Corinth. As a result, we are brought closer to the whirring mechanisms of Lichtenstein's imagination.

Finally, I would like to thank my agent, Rosemary Scoular, and my editor, Ben Brusey, for their advice and encouragement, as well as Donna Poppy and Ellie Smith for their keen-eyed assistance.

Select Bibliography

Bader, Graham. *Hall of Mirrors: Roy Lichtenstein and the Face of Painting in the 1960s*. Cambridge, Massachusetts, and London: MIT Press, 2010.

Bastian, Heiner. *Andy Warhol: Retrospective*. London: Tate Publishing, 2001.

Cohen-Solal, Annie. *Leo and His Circle: The Life of Leo Castelli*. Translated by Mark Polizzotti with the author. New York: Alfred A. Knopf, 2010.

Collins, Bradford R. 'Modern Romance: Lichtenstein's Comic Book Paintings', *American Art*, 17, 2 (Summer, 2003), pp. 60–85.

Collins, Bradford R. *Pop Art: The Independent Group to Neo Pop, 1952–90*. London and New York: Phaidon Press, 2012.

Danto, Arthur C. *Andy Warhol*. New Haven and London: Yale University Press, 2009.

Foster, Hal. *The First Pop Age: Painting and Subjectivity in the Art of Hamilton, Lichtenstein, Warhol, Richter, and Ruscha*. Princeton and Oxford: Princeton University Press, 2012.

Kotz, Mary Lynn. *Rauschenberg: Art and Life*. New York: Harry N. Abrams, 2004.

Lichtenstein: Girls. With contributions from Richard Hamilton, Jeff Koons, Dorothy Lichtenstein and Richard Prince. Gagosian Gallery. Distributed by Yale University Press, 2008.

Lobel, Michael. *Image Duplicator: Roy Lichtenstein and the Emergence of Pop Art*. New Haven and London: Yale University Press, 2002.

Marquis, Alice Goldfarb. *The POP! Revolution: How an Unlikely Concatenation of Artists, Aficionados, Businessmen, Collectors, Critics, Curators, Dealers, and Hangers-On Radically Transformed the Art World*. Boston: MFA Publications, 2010.

Moorhouse, Paul. *Pop Art Portraits*. With an essay by Dominic Sandbrook. London: National Portrait Gallery Publications, 2007.

POP. Edited by Mark Francis. Survey by Hal Foster. London and New York: Phaidon Press Limited, 2005.

Ratcliff, Carter. 'The Work of Roy Lichtenstein in the Age of Walter Benjamin's and Jean Baudrillard's Popularity', *Art in America*, 77, 2 (Feb. 1989), pp. 111–22, 177.

Rondeau, James, and Wagstaff, Sheena. *Roy Lichtenstein: A Retrospective*. The Art Institute of Chicago and Tate Modern, London. Distributed by Yale University Press, 2012.

Roy Lichtenstein. Edited by Graham Bader. Cambridge, Massachusetts, and London: MIT Press, 2009.

Tomkins, Calvin. *Off the Wall: A Portrait of Robert Rauschenberg*. New York: Picador, 2005.

Varnedoe, Kirk, and Gopnik, Adam. *High & Low: Modern Art and Popular Culture*. New York: Museum of Modern Art, 1990.

Waldman, Diane. *Roy Lichtenstein*. New York: Harry N. Abrams, 1971.

Whiting, Cecile. *A Taste for Pop: Pop Art, Gender, and Consumer Culture*. Cambridge: Cambridge University Press, 1997.